snius genius imagination inspiration

clever **Creativity** inventive

thankful **Gratitude** grace

honor debt humility

vision talent originality recognition praise profound

WRITE THE POEM

transmutation switch variance

season **Change** shift

revision metamorphosis transition

voyage

tour trip

expedition **Travel** trek

touring wandering ramble

tune choral rhythm

popular **Music** melody

orchestra instrumental hymn

enchantment flame youth

passion **First Love** tenderness

cherishing yearning relish

sultry dog days seaside

sweat **Summer** sunshine

vacation beach heat

Follow us on social media!

Tag us and use #piccadillyinc in your posts
for a chance to win monthly prizes!

This edition published by Piccadilly (USA) Inc.

Piccadilly (USA) Inc.
12702 Via Cortina, Suite 203
Del Mar, CA 92014
USA

10 9 8 7 6 5 4 3 2 1

Printed in China

ISBN-13: 978-1-60863-406-4

Write a poem about
The Ocean

Word
Associations

billows

deep

brine

offing

wave

flux

tide

current

Write a poem about
Clouds

puff
mist
billow
blanket
swarm
thunderhead
nebulous
cumulous

Write a poem about
First Love

Word
Associations

tenderness

relish

flame

yearning

cherishing

passion

enchantment

youth

Write a poem about
Spring

budding

flowering

vernal

seedtime

beginnings

fresh

perennial

primrose

Write a poem about

A Tree

sapling
woods
leaves
greenery
roots
branches
timber
forest

Word Associations

roaring

raging

blustering

tempestuous

squall

blast

gale

wrath

Write a poem about
A Storm

Write a poem about

A Sunny Day

Word
Associations

luminous
summery
shining
clarion
radiant
brilliant
bask
haze

Word Associations

acrimony
ire
enmity
indignation
vexation
choler
rage
malice

Write a poem about
Anger

Write a poem about
Sadness

Word
Associations

heartache
bleakness
dysphoria
woe
grief
despondent
sorrow
suffering

Write a poem about
Joy

glee

rapture

ecstasy

bliss

cheer

contentment

delight

elation

Write a poem about

Tears

Word
Associations

crying

distress

grieving

sorrow

pain

weep

wailing

whimpering

Write a poem about
Rain

deluge
showers
dew
precipitation
torrent
raindrops
sprinkle
liquid sunshine

Write a poem about
Illness

Word
Associations

malady
breakdown
affliction
ailing
relapse
disability
convalescence
recovery

Word
Associations

Write a poem about
Smiles

grin
laugh
amusement
delight
smirk
beam
dimple
lips

Write a poem about
Music

Word
Associations

melody
hymn
instrumental
orchestra
popular
tune
choral
rhythm

Write a poem about
Travel

trek

ramble

wandering

touring

expedition

tour

voyage

trip

Write a poem about
Fame

Word
Associations

renown

repute

standing

acknowledgement

reputation

popularity

regard

immoral

Word Associations

verse
rhyme
stanza
composition
muse
rhythm
lyric
epic

Write a poem about
Poetry

Write a poem about
Wishes

intention

aspiration

ambition

hope

longing

will

yearning

desire

Word Associations

fantasy

trance

thought

image

illusion

mental picture

fancy

vision

Write a poem about

Dreams

Write a poem about
Hopes

expectation

wish

aspiration

ambition

belief

optimism

faith

anticipation

Write a poem about
Mortality

fatal
lethal
life
paradise
passing
repose
silence
sleep

Write a poem about

Heaven

Word
Associations

Kingdom
glory
eternity
bliss
beyond
afterworld
hereafter
eternal rest

Word Associations

guardian
idol
nurture
mother
father
childhood
upbringing
teacher

Write a poem about

Parents

Write a poem about
Children

Word
Associations

toddler
play
offspring
kids
little
foundling
youngsters
youth

Write a poem about
Home

house

fireside

village

kitchen

hearth

cottage

apartment

tenement

Write a poem about
Work

toil
labor
wage
artisan
skill
exertion
effort
grind

Word Associations

imbibe

taste

chew

eat

digest

masticate

cuisine

diet

Write a poem about
Food

Write a poem about

Time

eternity

hours

period

era

clock

ticktock

infinity

moment

Word
Associations

Write a poem about
The Past

memory
distant
history
remembrance
antiquity
memoir
bygone
long ago

Write a poem about
The Future

destiny
hope
potential
imminent
opportunity
fate
foresee
prophesy

Write a poem about
Education

knowledge
smart
learn
teach
training
enlightenment
intelligence
schooling

Write a poem about
A Garden

Word
Associations

flower
petals
soil
roots
seed
rosebud
Eden
terrace

Word
Associations

Write a poem about
Ice

chill
freeze
glacier
crystal
winter
iceberg
frigid
frozen

Write a poem about
Science Fiction

Word
Associations

space
alien
explore
abduction
invasion
future
humanoid
galaxy

Write a poem about
A Historical Figure

president

activist

revolutionary

captain

author

conqueror

hero

leader

Write a poem about
Responsibility

Word
Associations

cross
burden
leadership
obligation
safeguard
onus
charge
bond

Word Associations

candor

purity

reality

fact

certainty

genuine

honesty

authentic

Write a poem about
Truth

Write a poem about
Dedication

Word
Associations

devotion
allegiance
commit
piety
constancy
zeal
loyalty
fervor

Word Associations

Write a poem about

Love

adoration

affection

yearning

flame

emotion

ardor

fondness

rapture

Write a poem about
Deceit

Word
Associations

trickery
duplicity
lies
guile
two-faced
imposter
pretense
fraud

Word Associations

bustle
din
clamor
tumult
uproar
thunder
crescendo
cacophony

Write a poem about
Noise

Write a poem about
Loneliness

Word
Associations

isolation

empty

quiet

monotony

ache

silence

longing

seclusion

Word Associations

jittery
dread
uneasy
fretful
disquietude
distress
restless
apprehension

Write a poem about
Anxiety

Write a poem about
An Animal

Word
Associations

fur

tail

beast

untamed

wild

creature

mammal

feral

Write a poem about
A Pet

companion
dog
cat
turtle
rabbit
snake
company
parrot

Write a poem about
Snow

Word
Associations

white
drifts
hush
chill
flurry
blizzard
flake
frost

Word Associations

flow
course
unstoppable
rushing
waterway
wade
bridge
rapids

Write a poem about
A River

Write a poem about
Mountains

Word
Associations

peak

summit

climb

valley

slope

ascent

crag

precipice

Write a poem about

A Stranger

friend or foe
sojourner
mysterious
guest
newcomer
migrant
visitor
acquaintance

Write a poem about
War

Word
Associations

combat

hostility

strife

bloodshed

allies

enemy

army

conflict

Write a poem about
Heroism

courage
sacrifice
unflinching
strength
valiant
gallant
bold
daring

Write a poem about
Cowardice

Word
Associations

spineless
weak
timid
afraid
abject
pathetic
wimp
deserter

Word Associations

comradeship
fraternity
loyal
steadfast
solidarity
partner
unity
fellowship

Write a poem about
Brotherhood

Write a poem about
A Work of Art

portrait
brushstrokes
texture
color
craft
landscape
shade
light

Write a poem about
The Night Sky

stars

blackness

moonlight

midnight

pitch

constellations

glimmer

wakeful

Write a poem about

The Moon

Word
Associations

crescent

sphere

orb

silver

tide

wane

lunar

Apollo

Write a poem about
The Sun

golden
effulgence
solstice
radiance
heat
dappled
shadow
zenith

Write a poem about
Imperfection

Word
Associations

flaw
uniqueness
foible
blemish
shortcoming
nature
defect
marred

Word Associations

Write a poem about
Chance

luck

fortune

random

fate

remote

providence

gamble

destiny

Write a poem about
Serendipity

karma

kismet

circumstance

divine

fluke

break

happenstance

unexpected

Word
Associations

Write a poem about
Perfection

flawless

supreme

paragon

diamond

pure

ideal

sublime

unattainable

Write a poem about
A Window

Word
Associations

sill

pane

view

light

panorama

curtain

shutter

glass

Write a poem about
Change

shift

transition

metamorphosis

revision

season

switch

transmutation

variance

Write a poem about
Kisses

Word
Associations

lips

cheek

warm

wet

clasp

passion

caress

embrace

Write a poem about
Evil

demon
wicked
malignity
villain
harm
corrupt
nefarious
vile

Write a poem about
Temptation

Word
Associations

covet

allure

bait

enticing

tantalize

draw

seduction

irresistible

Write a poem about
Justice

right
code
moral
truth
fair
redress
recompense
rule

Write a poem about
Inequality

Word
Associations

unfair
injustice
racism
difference
bias
disparity
privilege
misfortune

Write a poem about
Knowledge

education

philosophy

light

scholarship

expertise

theory

wisdom

judgement

Write a poem about
Freedom

Word
Associations

independence
autonomy
opportunity
liberation
range
ability
laissez faire
indulgence

Write a poem about
A Waterfall

cascade
power
possibility
rapids
spray
foam
roaring
pool

Write a poem about
Creativity

inventive
originality
talent
vision
clever
imagination
genius
inspiration

Word Associations

grace
profound
praise
recognition
thankful
honor
debt
humility

Write a poem about
Gratitude

Write a poem about
Faith

Word
Associations

adoration

certainty

trust

fealty

belief

conviction

confidence

dogma

Word Associations

harm
brutality
aggression
pain
injury
attack
assault
tumult

Write a poem about
Violence

Write a poem about
Tragedy

Word
Associations

doom
adversity
death
wreck
catastrophe
affliction
misfortune
curse

Word Associations

sunshine

heat

beach

vacation

sweat

sultry

dog days

seaside

Write a poem about
Summer

Write a poem about
Winter

Word
Associations

snow

chill

solstice

igloo

yule

fireside

evergreen

arctic

Word Associations

autumn

orange

foliage

harvest

leaves

branches

cornucopia

death

Write a poem about
Fall

Write a poem about
Ecology

Word
Associations

preservation
conservation
ecosystem
environment
science
nature
Earth
planet

Write a poem about
Spirituality

God
otherworldly
worship
creed
principle
faith
teachings
passion

Write a poem about

Prayer

invocation
entreat
appeal
humble
thanks
psalm
deliverance
blessing

Word Associations

comfort
tenderness
sharing
closeness
reassurance
glow
affection
radiate

Write a poem about
Warmth

Write a poem about
Scared

aghast
stricken
fearful
danger
risk
unsure
panic
afraid

Word Associations

values
custom
heritage
legend
fable
culture
folklore
convention

Write a poem about
Tradition

Write a poem about
A Glance

Word
Associations

brief
impression
fleeting
shy
blink
eye contact
peek
flash

Word Associations

bereaved
loss
sorrow
tears
lament
anguish
heartache
woe

Write a poem about
Grief

Write a poem about
Beauty

Word
Associations

behold

brilliance

lovely

pathos

muse

elegance

striking

exquisite

Word Associations

wholehearted

innocence

artless

honesty

guileless

simple

genuine

plain

Write a poem about

Sincerity

Write a poem about

Captivity

Word
Associations

caged
imprisonment
bondage
unfree
ransom
prison
hostage
bound

Word Associations

awe
marvel
curiosity
jolt
reverence
admiration
perplexity
fascination

Write a poem about
Wonder

Write a poem about
Affection

Word
Associations

crush

itch

amore

devotion

caring

warmth

tingle

tender

Write a poem about
Bliss

joy
euphoria
paradise
rapture
glory
nirvana
ecstasy
completeness

Write a poem about
Broken Heart

stricken

heartsick

pain

doleful

betrayal

vulnerable

crushed

regret

Write a poem about
A Walk

stroll

fresh air

pulse

footsteps

path

promenade

breeze

wander

Write a poem about
Intelligence

Word
Associations

insight
literate
shrewd
brains
discern
mind
brilliance
sense

Write a poem about
A Bird in Flight

freedom

soar

glide

voyage

wing

perspective

omen

breeze

Write a poem about
Flavors

Word
Associations

taste

sweet

zest

savor

essence

spicy

tang

relish

Word Associations

lion
dignity
pomp
ostentation
arrogance
boast
confidence
ego

Write a poem about
Pride

Write a poem about

Weakness

Word
Associations

debility
frailty
lack
folly
vice
shortcoming
feeble
vulnerability

Write a poem about
Loss

destitute

waste

grief

cost

lacking

need

mourning

defeat

Write a poem about
Health

Word
Associations

fortitude

fettle

form

tone

vigor

potency

robust

hardy

Write a poem about
Confidence

esteem

brashness

assurance

morale

poise

tenacity

conviction

dignity

Write a poem about
Marriage

Word
Associations

couple

alliance

love

wedlock

matrimony

mate

courtship

pledge

Write a poem about

Security

salvation
care
arms
defense
immunity
pledge
refuge
precaution

Write a poem about
Possibilities

Word
Associations

potential

limitless

foresight

promise

action

hazard

plausible

shot

Word Associations

Write a poem about

Virtue

paragon

merit

ethical

righteous

purity

charity

worthy

upright

Write a poem about
Shock

Word
Associations

crash

spark

wreck

stupor

trauma

jolt

disbelief

paralysis

Word Associations

experience
adult
sophistication
wisdom
prime
ripe
advanced
apt

Write a poem about
Maturity

Write a poem about
Treasure

Word
Associations

trove

precious

rare

wealth

value

abundance

fortune

cache

Word Associations

stock

sure

credence

conviction

loyal

integrity

charge

steadfast

Write a poem about
Trust

Write a poem about
Compassion

Word
Associations

benevolence

meek

tenderness

empathy

heart

clemency

mercy

softness

Word Associations

Write a poem about

The Universe

cosmos

creation

infinite

totality

relativity

immense

vast

space

Write a poem about
A Fragrance

Word
Associations

bouquet

balm

aroma

savory

musk

honeysuckle

intoxicate

subtle

Word Associations

horizon

scope

dreams

visions

prospect

seize

carpe diem

luck

Write a poem about
Opportunities

Write a poem about
Meditation

Word
Associations

rumination

reflection

peace

introspection

tranquil

rapt

Zen

ponder

Write a poem about
Equality

parity
tolerance
balance
acceptance
fair
level
right
brotherhood

Write a poem about
Independence

Word Associations

freedom

sovereign

self-reliance

autonomy

strength

confidence

assuredness

determination

Word Associations

incorrupt
honorable
constant
solid
trusty
staunch
decency
upright

Write a poem about
Reliability

Write a poem about

Challenges

Word
Associations

odds

trials

dare

gauntlet

moxie

overcome

persevere

obstacle

Write a poem about
Patience

stoic
serene
calm
peace
composure
humility
gentleness
placid

Write a poem about

Perspective

viewpoint

context

scene

vista

shift

frame

broad

angle

Write a poem about
A Voyage

passage
jaunt
journey
crossing
discovery
vessel
explore
search

Write a poem about
Searching

hidden

quest

hunt

trace

rove

scour

pursue

comb

Word Associations

occasion
flash
instant
present
pause
savor
twinkling
linger

Write a poem about
Moments

Write a poem about
Frustration

Word
Associations

vexation
hindrance
chagrin
failure
obstruction
foiled
bitter
setback

Word Associations

Write a poem about
Control

govern

dominion

restraint

clout

authority

direct

sway

monitor

Write a poem about

Expectations

Word
Associations

promise

notion

supposition

design

motive

prospects

hope

potential

Word Associations

oneness

harmony

peace

solidarity

coherence

unanimity

collective

global

Write a poem about
Unity

Write a poem about
Blessings

Word
Associations

gifts

grace

thanks

benediction

luck

boon

bestow

bounty

Write a poem about
Values

mores

scruples

ethics

standards

conscience

ideals

code

tenet

Write a poem about

Laughter

Word
Associations

joy
belly
medicine
shriek
howl
merriment
rejoice
burst

Word Associations

hush
lull
peace
calm
quietude
stillness
whisper
profound

Write a poem about
Silence

Write a poem about

Insecurity

Word
Associations

doubt

hesitancy

uncertainty

struggle

fear

exposed

misgiving

caution

Write a poem about
Solitude

alone

isolation

seclusion

recluse

introvert

private

remote

hermit

Write a poem about
Achievement

award

brass ring

accomplishment

success

posterity

crowning

victory

triumph

Word Associations

infinity
everlasting
perpetual
endless
future
immortality
eon
lasting

Write a poem about
Eternity

Write a poem about

Romance

Word
Associations

thrill

amour

affair

flirtation

entangle

intimacy

passion

desire

Write a poem about
Adventure

enterprise

exploit

undertaking

escapade

climb

dare

gamble

voyage

Write a poem about
Angels

Word
Associations

guardian
ascend
ethereal
heavenly
spirit
cherub
seraph
being

Write a poem about
Appreciation

gratitude
tribute
thankful
salute
favor
regard
esteem
veneration

Write a poem about

Carpe Diem

Word
Associations

live

pluck

seize

dare

boldness

endeavor

audacity

nerve

Write a poem about
Character

reputation

attitude

badge

constitution

cast

tone

nature

temperament

Write a poem about
Colors

Word
Associations

pigment
shade
tincture
complexion
scarlet
cobalt
brilliance
vermillion

Word Associations

obscure
bewilderment
turmoil
fluster
tangle
leather
turbulence
shaken

Write a poem about
Confusion

Write a poem about
Conflict

Word
Associations

fray
breach
clash
rival
contest
embroil
protagonist
strife

Word Associations

prowess

spunk

intrepidity

fortitude

lion-hearted

dauntless

guts

pluck

Write a poem about
Courage

Write a poem about
Creation

Word
Associations

spark

existence

genesis

animate

formation

nativity

origin

foundation

Write a poem about
Devotion

piety
loyalty
fidelity
earnest
sanctity
fealty
deference
service

Write a poem about
Family

Word
Associations

kin
lineage
clan
tribe
blood
kindred
relationships
generation

Word
Associations

Write a poem about

Forgiveness

clemency
compassion
mercy
absolution
lenience
charity
grace
repent

Write a poem about
Friendship

Word
Associations

pact
brotherhood
sisterhood
league
alliance
bond
rapport
camaraderie

Word Associations

surge
prosper
flowering
sprout
swell
unfold
boost
bud

Write a poem about
Growth

Write a poem about
Hate

Word
Associations

ire

venom

spite

scorn

malevolence

aversion

bile

wrath

Write a poem about
History

yesterday
past
antiquity
bygone
ancient
annals
chronicle
story

Write a poem about
Humanity

Word
Associations

people
mankind
good will
fellowship
civility
uprightness
forbearance
compassion

Word
Associations

Write a poem about
Humility

reserve

bashfulness

docile

meek

fawn

modesty

contrition

gentle

Write a poem about
Imagination

Word
Associations

vivid

invention

fantastic

stimulating

vision

enterprise

originality

artistry

Word Associations

virtue
clean
lamb
impeccable
artless
modesty
decency
temperance

Write a poem about
Innocence

Write a poem about
Inspiration

Word
Associations

whimsy

insight

elation

fervor

delight

talent

fancy

revelation

Write a poem about
A Journey

pilgrimage
sojourn
roam
traverse
odyssey
expedition
circumnavigation
wander

Write a poem about
Judgement

Word
Associations

acumen

savvy

reason

intuition

sense

perception

prudence

wisdom

Write a poem about

Longing

craving

entreaty

throb

lovesick

thirst

pining

hope

languish

Write a poem about

Moving On

hasten

momentum

go forth

launch

progress

proceed

continue

push

Word Associations

conundrum
pickle
quandary
crux
enigma
puzzlement
charade
baffle

Write a poem about
A Mystery

Write a poem about
Paradise

Word
Associations

eden

Elysium

heaven

bliss

delight

utopia

transport

nirvana

Write a poem about
Passion

ardor
fervor
intensity
heat
zest
lust
desire
zeal

Write a poem about

Peace

order

truce

unity

amity

quiet

harmony

tranquility

joy

Write a poem about
Sleep

dream
doze
Morpheus
repose
torpor
trance
slumber
somnolence

Write a poem about
Sorrow

pang

mourning

misery

agony

bereavement

melancholy

woe

suffering

Word Associations

partner
lover
spouse
kindred
confidante
companion
true love
sweetheart

Write a poem about
Soul Mate

Write a poem about
Strength

vitality

fortitude

health

power

muscle

sinew

pith

potency

Word
Associations

Write a poem about
A Sunset

eventide
gloaming
nightfall
dusk
orange
gold
decline
twilight

Write a poem about
Visions

Word
Associations

perception
glimpse
insight
acumen
brilliance
fancies
musings
imagination

Word Associations

Write a poem about

Nighttime

sleepless

moonless

darkness

wakeful

vigil

dim

shadow

black

Write a poem about
Growing Older

Word
Associations

golden years
mature
dotage
decline
elder
venerable
evolved
perfected

Write a poem about
A Choice

marriage
path
challenge
alternative
dilemma
passion vs. logic
popular
ballot

Write a poem about
Jealousy

Word
Associations

rivalry

envy

antagonism

animosity

spite

grudge

covetous

strife

Word Associations

dread

tremor

paralyzed

foreboding

nightmare

creeps

jitters

angst

Write a poem about
Fear

Write a poem about
A Breath

Word
Associations

inspire

expand

renewal

energize

gasp

wind

freshen

depth

Word
Associations

Write a poem about
Betrayal

duplicity
perfidy
Judas
Brutus
trickster
double
heartbreak
treason

Write a poem about
A Shadow

two-faced
dark side
lightless
mimic
obfuscate
blacken
obscure
extinguish

Write a poem about
Society

trend
media
opinion
populism
fashion
responsibility
outcast
progress

Write a poem about
Seeds

Word
Associations

beginnings
ideas
kernel
core
concept
embryo
germ
stem

Word Associations

oblivion
disremember
consign
escape
pass
omit
scorn
clean slate

Write a poem about
Forgetting

Write a poem about
Luck

Word
Associations

stroke

profit

win

windfall

break

avail

odds

fortune

Word Associations

penitence
self-reproach
repine
bitterness
lament
bemoan
rue
defeat

Write a poem about
Regret

Write a poem about
Confessions

Word
Associations

misdeeds

mistake

absolution

regrets

contrition

guilt

sacrament

forgiveness

Word Associations

matriarch
origins
childhood
warm
womb
complex
goddess
caregiver

Write a poem about
Mother

Write a poem about
Insanity

Word
Associations

delirium
lunacy
mania
irrational
incoherent
delusion
neurosis
folly

Word Associations

cryptic
dark
hush
private
clouded
mist
regret
buried

Write a poem about
A Secret

Write a poem about

A Surprise

Word
Associations

sudden

exclaim

unexpected

epiphany

godsend

ambush

astound

baffle

Word Associations

bind
choice
boxed in
impasse
scrape
plight
mess
quagmire

Write a poem about
Dilemma

Write a poem about

A Voice

Word
Associations

murmur

whisper

holler

soft

husky

sultry

conscience

instinct

Word
Associations

Write a poem about
Sharing

support
cooperation
ration
teamwork
collaboration
sacrifice
charity
generosity

Looking for more?

Similar titles available by Piccadilly:

300 Writing Prompts

300 MORE Writing Prompts

500 Writing Prompts

3000 Questions About Me

3000 Would You Rather Questions

Choose Your Own Journal

Complete the Story

Your Father's Story

Your Mother's Story

The Story of My Life

Write the Story

300 Drawing Prompts

500 Drawing Prompts

Calligraphy Made Easy

Comic Sketchbook

Sketching Made Easy

100 Life Challenges

Awesome Social Media Quizzes

Find the Cat

Find 2 Cats

Time Capsule Letters

WWW.PICCADILLYINC.COM